How To Take Great Photographs With Any Camera

Pocket Edition

Jerry Hughes

PHILLIPS LANE PUBLISHING
5521 Greenville Avenue, Suite 104-PMB732
Dallas, Texas 75206
www.takegreatphotos.com

FOREWORD

A famous photographer was once asked, "Sir, what kind of camera do I buy my son to take photograph's like you." The photographer replied, "What kind of piano would you buy him to play like **Mozart**?" A photographer's knowledge is more important than their equipment.

Buying the best football won't get you into the Super Bowl, great golf clubs don't get you into the Masters. The "**great camera** makes a great photographer" myth, has left many great cameras on closet shelves.

Some people say creativity can't be taught, you must be born with it. The **C.A.L.L.™** Creative Method helps anyone learn to see creatively. It simplifies photography into four basic creative choices. These four can be combined in an infinite number of ways for great photographs.

Three primary colors combine to make up all color, seven notes all music, four C.A.L.L.™ basics all photographs. These creative fundamentals are **choices** the photographer must make. They are beyond the camera's control so they will work with any camera.

Over 300 "How to" photos, sketches and captions explain complex ideas in simple terms. The Quick-Read™ layout makes it a timesaver using large type and simple wording. Black and white photos show right and wrong examples more clearly than color. It is small enough to carry in your camera case for **quick reference**. Have fun taking better photographs for the rest of your life and enjoy the compliments.

Very Truly,

Jerry Hughes

Thanks to Dad and Mom
for all the love and support.

Love,

Jerry

CHAPTERS PAGES

Study Cards: To study great photos & review yours

Composition

Frame: _____

Crop: _____

Place: _____

Angle

Walk-around: _____

Camera height: _____

Camera tilt: _____

Lighting

Four types: _____

Time of day: _____

Lighting tools: _____

Lens

Wide-angle: _____

Normal: _____

Telephoto: _____

Location: _____ **Film:** _____

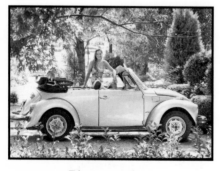

Photograph

Composition
Frame: *Horizontal*
Crop: *3/3*
Place: *Full Frame*

Angle
Walk-around: *Left Side*
Camera height: *Normal*
Camera tilt: *Slight Tilt*

Lighting
Four types: *Back Light*
Time of day: *Morning*
Lighting tools: *Back Light*

Lens
Wide-angle: _____
Normal: *Normal*
Telephoto: _____

Location: *Driveway at home* **Film:** *400 Speed*

Study card lists creative choices, *like a recipe for the photograph.*

COMPOSITION

Composition

You can combine framing, cropping and placement into many creative combinations. Using these three you can make many creative photographs.

Look at magazine covers, advertisements, movies and television to see how they compose their subjects. Look at photographs you have taken and see how they are composed.

Framing

You can frame your subject horizontal, vertical, or at a funky tilt™. You can photograph a vertical subject vertically, try it horizontally, or even at a funky tilt.

Look at or try all three and see what you like. How you crop or place the subject can make a difference also.

Cropping

You can crop your subject by thirds, 3/3 full length, 2/3 or 1/3. You can crop loose or tight by thirds. The subject can be centered if it fills the frame. If the subject is placed full length in a scene you can choose how much of the background to show. Take an overall photograph and then crop in for details. Cropping is what you leave in and what you leave out.

Placement

You can place your subject on thirds lines, left & right, top & bottom. Place the center of interest on a Hot Spot where the 1/3 lines cross. You can center the subject if it **fills** the photograph. If it has a lot of space around it you need to place it using thirds.

Composition: Frame, Crop and Place your subject

Frame

Horizontal

Vertical

Funky Tilt ™

Cropping

3/3

2/3

1/3

Placement

Left or right 1/3 line

Top or bottom 1/3 line

Hot Spot

Frame subject Horizontal, Vertical or Funky Tilt™

Horizontal

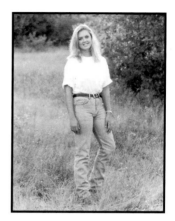

Vertical

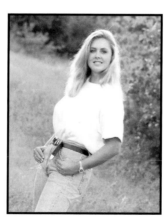

Funky Tilt™

Crop subject by thirds

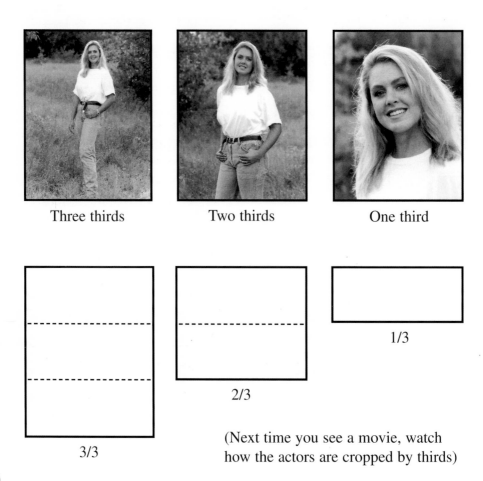

Three thirds Two thirds One third

3/3

2/3

1/3

(Next time you see a movie, watch
how the actors are cropped by thirds)

Crop subject loose or tight

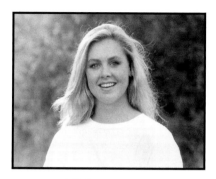

1/3 Loose crop

1/3 Tight crop

Crop in for details

Details

Details

Details

11

Place subject on left 1/3 line

Left 1/3 line

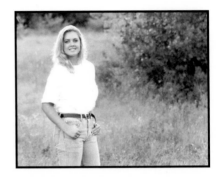

Left 1/3 line
(Filming a movie, actors are placed
on the left or right 1/3 of the frame)

or place subject on right 1/3 line

Right 1/3 line

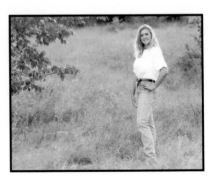

Right 1/3 line

Place subject on top 1/3 line

Subject on Top 1/3 line

Subject on Top 1/3 line
Less background-more foreground

or place subject on bottom 1/3 line

Subject on Bottom 1/3 line

Subject on Bottom 1/3 line
Less foreground-more background

Place subject on a Hot Spot where 1/3 lines cross

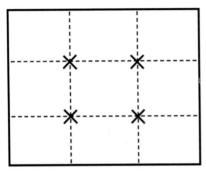

Four Hot Spots / Horizontal
top/left or top/right
bottom/left or bottom/right

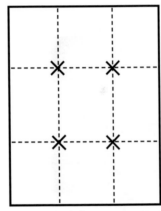

Four Hot Spots / Vertical

Don't center subject and leave photo half empty

Use focus circle to focus,
not to place your subject

Subject's head centered in focus circle
and top half of photo is empty

Place subject or center of interest on a Hot Spot

Bottom/Left Hot Spot

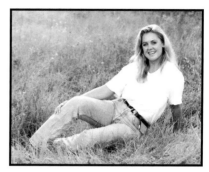

Top/Right Hot Spot
(Okay to center subject if it fills frame)

Top/Left Hot Spot

Bottom/Right Hot Spot

Viewfinder camera: Look thru viewfinder not lens

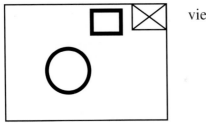

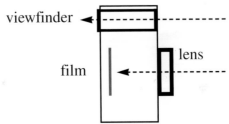

Viewfinder camera
Front view

Viewfinder: Side *cut-away* view
View of subject thru opening
in camera body above lens

Single Lens Reflex camera: Look thru lens

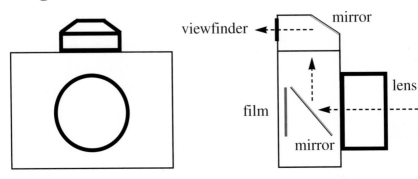

Single Lens Reflex camera
Front view

SLR: Side *cut-away* view
View of subject thru lens
using mirrors like periscope

Cropping into peoples heads: Viewfinder vs. Lens

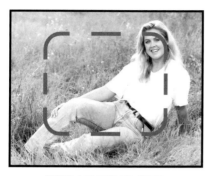

WHAT YOU SEE
Cropping lines in viewfinder
show edges of photograph

WHAT LENS SEES
Photograph showing what
was inside of cropping lines

Things in front of the lens don't show in viewfinder

Lens cap is on

Camera strap
in front of lens

Fingers in front
of lens (or flash)

Cropping: Compose, Focus, Shift and Shoot

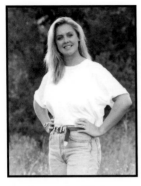

1. Crop & fill frame
with subject

2. Shift to focus on
subject

3. Shift back to fill
frame and shoot

Hold button halfway down to lock focus on subject

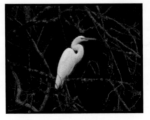

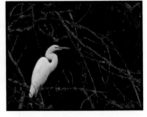

1. Place subject or
center of interest
on 1/3 line

2. Shift to focus on
subject (If auto focus
use focus lock)

3. Shift back to place
subject on 1/3 line or
hot spot and shoot

WALK-AROUND™ ANGLE

Walk-Around™ Angle

Your background, lighting, and subject change as you walk around your subject. You must find the best angle for all three of these. Don't just imagine what it looks like from other angles, walk and see.

Background

Your background will change as you walk around your subject. It can be more or less distracting, a light or dark area, in shade or bright sunlight. The foreground, what is in front of the subject also changes. Small movement can make a big difference in the relationship of the foreground, subject and background, even on large subjects. Watch out for things like telephone poles and trees coming out of peoples heads.

Lighting

Your lighting changes as your angle to the light changes. The shadows change on the subject and background areas. With large subjects like mountains you must wait for the best time of day. See how shadows disappear as you get close to the same angle as the light.

Moveable Subject

You can move the subject into best light, in front of the best background and turn it to it's best angle.

Non-Moveable Subject

Find the subject's best angle, foreground and background. If the lighting isn't right you may have to come back at a better time of day. Look for the best angle on the subject and wait for the best light.

Walk-Around™ Angle: Background, Lighting, Subject

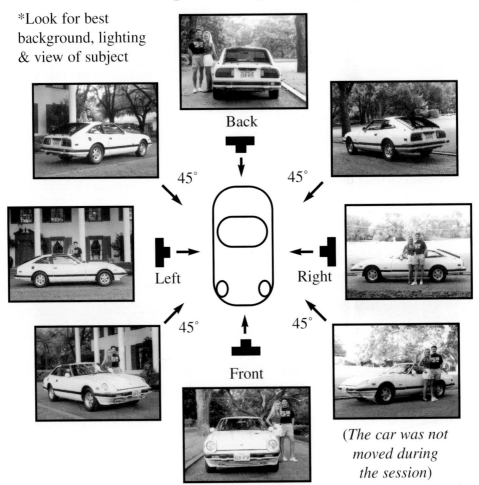

*Look for best
background, lighting
& view of subject

Back

45° 45°

Left Right

45° 45°

Front

(*The car was not
moved during
the session*)

Walk-Around™ to find best Background

Background distracting Background less distracting

Wide-angle shows more, Telephoto crops background

Wide-angle lens shows Telephoto lens shows
more background less background

Walk-Around™ to find best Lighting

 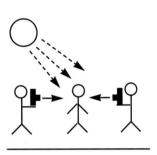

| Direct light: Sun in front of subject | (*Subject turned to face camera*) | Back light: Sun behind subject |

Shadows change on subject as you Walk-Around™

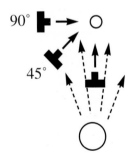

Bird's eye view Walking-around subject

Camera in line with light

Camera angle 45° to light

Camera angle 90° to light

Move Subject for best view, background and light

Subject in harsh light, turned from
camera with busy background

Subject moved into shade, turned to
camera with better background

Walk-Around™ non-moveable subject to find best angle of foreground, subject and background

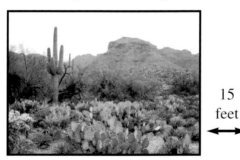

15
feet

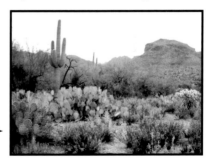

Mountain ridge close to cactus
small green cactus in foreground

Mountain ridge far from cactus
brown sage brush in foreground

Photograph down the side of a wall for shading

Bird's eye view of wall and subject

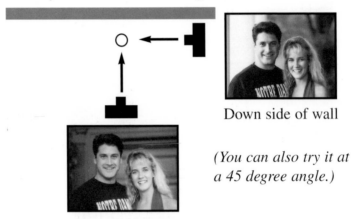

Down side of wall

(You can also try it at a 45 degree angle.)

Straight at wall

Walk-Around™ to separate background from subject

Dark on Light　　　Dark on Dark　　　Light on Light　　　Light on Dark

CAMERA HEIGHT

Camera Height

Low, normal and high camera angles affect the background, lighting and subject. You must find the best angle for all three.

Some people shoot everything from a standing position and each photo looks the same. Even a small change from sitting, standing or standing on a chair can make a big difference. Always be careful when choosing an angle.

Tilt or no tilt

High and low angles are dramatic, but they tilt the camera and can cause distortion. Keeping the camera back parallel to the subject creates a normal angle that is un-tilted and prevents distortion. Use a normal angle (untilted) for portraits. People don't like to be distorted.

Background

The background can become more or less distracting as you change your camera height. Be careful of where objects and horizon lines appear behind the subject.

Lighting

Shadows increase as you get lower than light source. Look at an object at home and see how shadows change as you change your height to light. Shadows disappear when you are at same height and angle as light.

Subject

Changing the camera height and tilt, changes the view of the subject. Kneeling down to a child's level helps prevent distortion. Distortion is like a building converging at top. More tilt gives more distortion.

Try a Low, Normal or High camera angle for subject

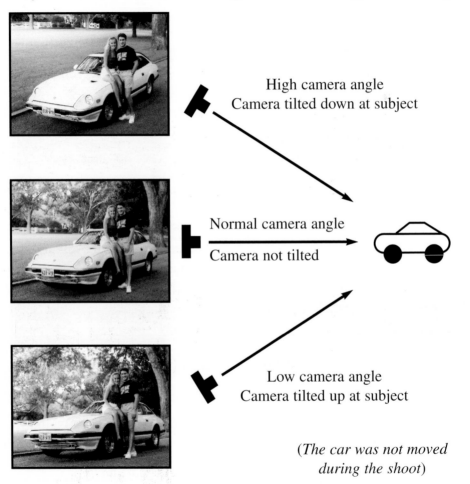

High camera angle
Camera tilted down at subject

Normal camera angle

Camera not tilted

Low camera angle
Camera tilted up at subject

(The car was not moved during the shoot)

Look for least distracting Background

Distracting background

Less distracting background

See how background changes at different heights

Low angle
Sitting on ground

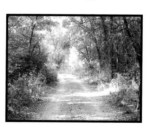

Normal angle
Standing

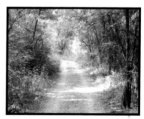

High angle
Standing on log

(Always be careful. Don't put yourself in a dangerous position when taking a photograph and pay attention)

Camera height to light affects Light and shadows

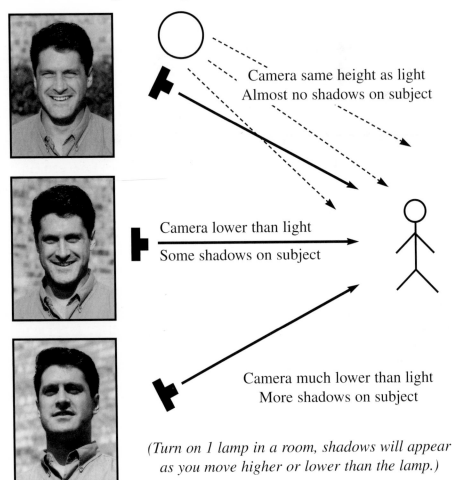

Camera same height as light
Almost no shadows on subject

Camera lower than light
Some shadows on subject

Camera much lower than light
More shadows on subject

*(Turn on 1 lamp in a room, shadows will appear
as you move higher or lower than the lamp.)*

Camera height changes view of subject

 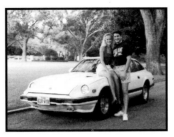

High camera angle
Camera tilted down

Normal camera angle
Camera not tilted

Low camera angle
Camera tilted up

Amount of camera tilt changed by distance and lens

Ground level

Ground level

15 feet away
telephoto lens

2 feet away
wide-angle lens

29

Use normal angle for portraits, avoid distortion

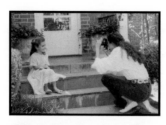

Photographer kneeling
to get on subject's level

Photographer standing
Camera tilted down
Subject is distorted

From kneeling position
Camera not tilted
No distortion

Wide angle distorts more than telephoto when tilted

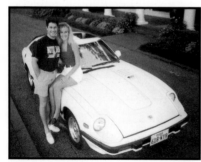

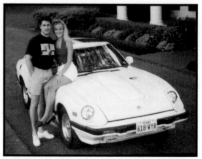

Camera tilted with wide-angle
lens causes more distortion

Camera tilted with telephoto
lens causes less distortion

FOUR TYPES OF LIGHT

Indirect Sunlight is Best

Indirect sunlight is softer because the light has reflected off or passed through something before it reached the subject.

Direct Light: DIRECT SUN

Direct sunlight puts **harsh** shadows on people's faces and makes them squint. In early days of photography people were told to put the sun in people's faces to make sure there was enough light for the film. Today's film is sensitive enough that you don't need direct sunlight to take a photo.

Indirect Light: SHADE

Shade is created by an object **blocking** the direct light from your subject. There is more light in **shade open** to sunlight, than in deep shade, where more sunlight is blocked. Shade near the edge of direct sunlight is the direct sunlight is the brightest.

Indirect Light: BACKLIGHT

Backlight has the sun behind the subject so it is standing in its own shade. The light on it is reflected from the surrounding area. It can be recognized by a rim of light around the edge of the subject. Backlight is a good way to **create shade** when there is no shade available. See the lighting ratio chapter about dealing with the bright background behind the subject.

Indirect Light: DIFFUSED

Clouds can diffuse or soften sunlight but the **high angle** of light at noon can still cause bad shadows. The long rays of light at sunrise and sunset are softened by the atmosphere. They are soft, have a great low angle and a warm glow.

Direct Light: Sun in front of subject

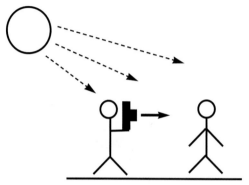

Direct sunlight can cause
harsh shadows on film

Person in Direct sunlight
(*Same person next 5 pages*)

Flowers in Direct sunlight

Scenic in Direct sunlight

Shade: Sun blocked to create shade

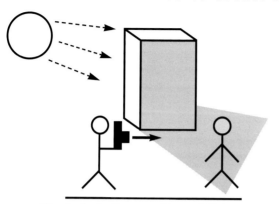

Shade is indirect reflected light
(Open shade has more light than deep shade)

Person in Shade
(Moved subject into shade)

Flowers in Shade
(Created shade with cardboard)

Scenic in Shade
(Waited for time of day)

33

Backlight: Sun behind subject

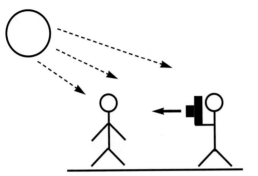

The subject creates it's own shade
*(Try using flash with backlight
to prevent dark silhouette)*

Person in Backlight
(Changed camera angle)

Flowers in Backlight
(Changed camera angle)

Scenic in Backlight
(Waited for time of day)

Diffused light: Sunlight softened by clouds

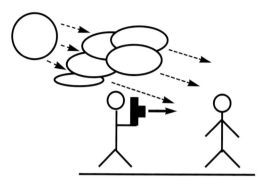

Clouds soften sunlight, be careful
of high angle and shadows at noon

Person in Diffused light
(*Clouds*)

Flowers in Diffused light
(*Sheet used to diffuse light*)

Scenic in Diffused light
(*Clouds*)

Diffused light: Sunrise/set softened by atmosphere

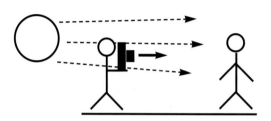

Sunrise and sunset have soft,
warm light from a great low angle

Person at Sunrise

Flowers at Sunset

Scenic at Sunrise

TIME OF DAY

Time of day

The time of day affects the angle of light and shadows it casts.

Noon

The sun is closest to the earth at noon and is the harshest. The high angle casts bad shadows on people and flat lighting on scenics. There are also fewer shaded areas and backgrounds to work in. Backlighting, shade diffused light and flash can help deal with the harsh light and high angle at noon.

Morning or afternoon

The sun is lower in the morning and after noon. An angle of light under 30° is generally best. Sunrise & sunset diffused by atmosphere is warm and at a low angle. More shaded areas and shape to scenics.

Moveable subjects

Even at noon you can move your subject into shade, under an overhang, turn it for backlighting, or use a flash.

To avoid lens flare you can use a lens shade or stand in the shadow of another object.

Non-moveable subjects

You can't control light on a mountain so you have to wait for best time of day or weather conditions for good light.

Sunrise and sunset are favorite times of day for nature, scenic and fashion photographers. Sometimes you have to wait for great light.

Don't refuse to photograph Buckingham Palace just because the light isn't good. Photographs are memories as well as art.

Time of day affects angle of light

For good light - any time of day, use lighting tools

- Put the subject in shade
- Turn subject for backlight
- Use flash

Noon
90° angle

Mid-morning
60° angle

Early morning
30° angle

Sunrise
0° angle

Direct light or backlight changes with time of day

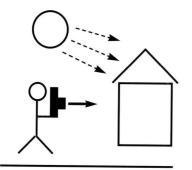 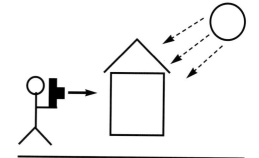

If the sun is in front of an area or object in the morning...

Then the sun will be behind the area or object in the afternoon

Harsh light at noon vs. Soft light in evening

Direct sunlight at noon
harsh light & shadows

Shade in evening at sunset
soft lighting and shadows

Non-moveable objects: Wait for best light

Noon
Harsh, flat lighting

Sunrise or sunset
Soft, round light

Light changes during the day

Backlight
in morning

Sunset

1/2 hour
after sunset

Sunrise and sunset are favorite times of day for scenic photographers

Moveable subject: Move subject into best light

Subject in direct
sunlight (harsh light)

Turn subject
for backlight

Move subject
into the shade

More shaded areas in morning and afternoon

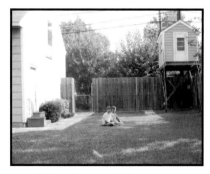

Noon
Less shaded areas to work in

Morning or Afternoon
More shaded areas to work in

41

Open shade has more light than deep shade

Open shade has more light. Deep shade has less light. *In deep shade you may need to use a flash or higher speed film*

Open shade has more light because it is directly reflected

Deep shade has less light, with reflected light blocked by more things

Sun low behind subject can cause flare into lens

Sunlight into lens can cause flare when sun is low, early or late in day

Sunlight blocked from lens with a lens shade, hand, or you standing in shade

LIGHTING RATIO

Lighting Ratio

This is the amount of light in the light area compared to the amount of light in the shadow areas. A three to one light ratio has three times as much light on the light area as in the shadow areas.

Eyes vs. Film & Paper

Film can't record both light and shadow areas at the same time if there is an extreme difference in the amount of light on them. Your eyes will see details that the film won't be able to record. Over a three to one ratio the shadows go black and highlights go white. You can squint your eyes to see the shadows darken.

Low Ratio v.s. High Ratio

A low light ratio has a 3-1 light ratio or less. A high light ratio has over a 3-1 light ratio.

Subject Ratio

The subject will have detail in both light and shadow areas with a low light ratio. It will lose detail in those areas with a high lighting ratio.

Subject to Background Ratio

The subject and background will both have detail in them with the same amount of light on both. If there is more light on one than the other, one will be too bright or too dark.

Lighting Tools

You can use flash, shade, or a change in camera angle for a background with the same amount of light as the subject. Backlight button, spot metering or filling the frame with the subject helps read the light on the subject, not the background. Indirect light is generally best.

Your eyes see detail in harsh light film can't record

Exposed for direct sunlight
Detail in light area,
detail lost in shadow area

Exposed for shade
Detail in shadow area,
detail lost in light area

Eyes-to-Brain better than Camera-to-Film-to-Print

Eyes can see up to a 10 to 1 ratio
10 times as much light in the
light area as the shadow area

Film needs a 3 to 1 ratio or less
3 times as much light in the
light area as the shadow area

Eyes to Brain
*Eyes & brain quickly adjust to both
direct light and shade areas*

Camera to Film to Print
*Film can't record detail in direct
light and shade at the same time*

Subject: Light ratio between light and shadow areas

| **Low** light ratio | **High** light ratio |
| *Small* difference between amount of light in light and shadow areas | *Big* difference between amount of light in light and shadow areas |

Subject to Background: Light ratio between them

Low light ratio
Small difference between amount of light on subject and background

High light ratio
Big difference between amount of light on subject and background

45

Set camera for light on subject not background

Camera set for amount of light
on background, subject dark

Camera set for amount of
light on subject

Use flash: It's an easy way to handle backlighting

Backlighted subject
with bright background

Flash adds light to subject and
helps even light with background

Flash on subject lightens shadows

Harsh light with dark shadows

Flash helps lighten shadows

SLR: Use spot meter, fill frame or backlight button

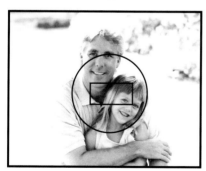

Use spot meter, if your camera has one, it measures light only in the small box in center

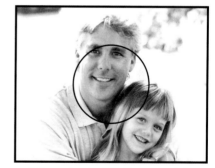

Move in to fill frame with subject to take meter reading from subject, not background

Outdoors: Use flash or fill flash

(Some cameras have a fill flash setting that balances the flash with the natural light)

Flash adds light outdoors

Symbol is a 1/2 Sun & lightening bolt

Fill Flash balances with the natural light

Amount of flash to natural light *(Lighting Ratio)*

Flash setting 2 weaker than existing light

Flash setting 1 weaker than existing light

Natural light No flash

Flash setting 1 stronger than existing light

Flash setting 2 stronger than existing light

LIGHTING TOOLS & FLASH

Shade

Shade blocks the direct light and is less harsh. You can place your subject in the shade or wait until the time of day when it is in the shade.

Backlight

Backlight can be used when there isn't any shade available. Look at movies and television for the rim of light or the halo on the hair. Backlight is soft because it is reflected from the area in front of the subject.

Overhang

Place the subject under an overhang that redirects light to a lower angle. You can find an overhang everywhere. Window, door light or even garage light can be great for portraits.

Flash recharge time

Give the flash time to recharge between shots, the further away the subject is the longer it takes. Check the flash ready light.

Flash as main light & fill light

Use indoors and outdoors for both main and fill light. Flash as main light provides light to take a photograph when there isn't enough light. Use flash as fill light when there is enough light but you want to fill in the shadows and lower the angle of light. Natural light looks good too so don't use flash all the time. Flash at sunset with backlight is fun too. You can get a ghost image from camera movement if you are moving when taking the photograph.

Preventing red eye

You need 2 inches between the flash and lens for every 5 feet you are from the subject.

Move subject into shade for better light

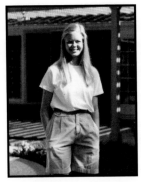

(Notice the difference when the subject is in bright sunlight and the background is in shade compared to when both subject and background are in shade)

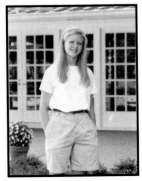

Subject in
direct sunlight

Subject moved
into shade

Turn subject's back to sun to shade the front

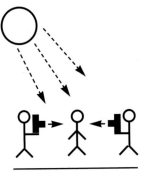

Direct sunlight
on front of subject

*(Subject turned
to face camera)*

Direct sunlight
on back of subject

Use flash or backlighting with spotted shade

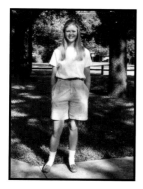

Spotted shade
thru tree leaves

Flash with
spotted shade

Subject turned
for backlighting

Block direct sunlight with a piece of cardboard

Subject in
direct sunlight

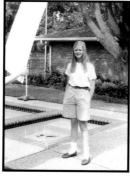

Holding a piece
of cardboard

Subject shaded
by cardboard

Use an overhang for a lower angle of light

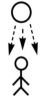 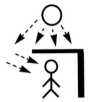

Subject in direct sunlight
with a high angle of light

Placing subject under overhang
redirects light to a lower angle

Look around to find overhangs to use

Porch or
awning

Window or
doorway

Tree or nature

Create an
overhang

How high is overhang above subject?

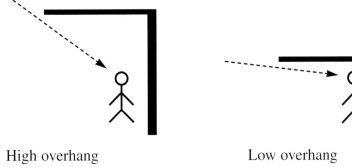

High overhang
Higher angle of light

Low overhang
Lower angle of light

How far under overhang is subject?

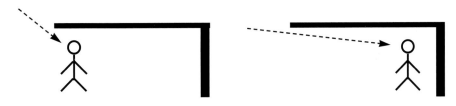

Subject at edge of overhang
Higher angle of light

Subject farther under overhang
Lower angle of light

(Move the subject from the front to the back of the overhang to find the light's best angle and sparkle.)

Minimum & Maximum built-in flash distances

Average minimum & maximum usable flash distances for cameras with built-in flash

5 feet 15 feet

*(Minimum **focusing** distance is generally 5 feet for disposable and point-&-shoot cameras.)*

Flash too close to subject

Flash too far from subject

■ Film speed affects maximum flash distances

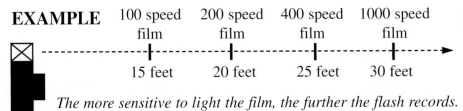

EXAMPLE

100 speed film	200 speed film	400 speed film	1000 speed film
15 feet	20 feet	25 feet	30 feet

The more sensitive to light the film, the further the flash records.

Wait for flash to fully recharge, check ready light

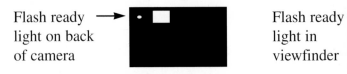

Flash ready light on back of camera

Flash ready light in viewfinder

The flash will recharge faster closer to the subject because it uses less power and the unused power is recycled into the next flash.

Indoors flash as main light, (*Use flash if not sure*)

Not enough light to
take photograph

Flash provides main
light for photograph

Outdoors flash as fill light, (*Try 1 flash -1 no flash*)

Light at high angle
can cause bad shadows

Flash provides lower angle
of light, fills in shadows

Red eye caused by flash located too close to lens

Flash too close to lens

Narrow angle of reflection
(light reflects straight back off eye)

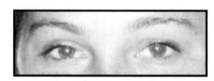

Red eye from flash reflecting off
the blood vessels in the eye
Pupils lighter and red

Rule: 2″ between flash & lens for each 5′ from subject

Flash located further from lens

Wider angle of reflection
(Light reflects off eye at an angle)

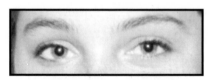

No red eye reflected with flash
at a higher angle from the lens
Pupil normal and not red

*(The roundness of the eye can
affect how red eye is reflected)*

Built in flash: Locate flash farther from lens

Camera with flash
located far from lens

Camera with a
pop-up flash

Camera with a
flip-up flash

Independent flash: Flash is farther from lens

Camera with independent
flash on top with hot shoe

■ Photo lab digital correction of red-eye

Most 1-hour photo labs can correct red-eye digitally from your negative or print. This digital print costs more than a regular print. They can send the photo out to have the work done if they cannot do it there. You can also have a photo CD made and do the corrections on your computer at home.

Blurred image with flash photo from existing light

(Camera movement can also cause a blur. Be sure to hold the camera steady.)

Flash stops action
with fast shutter speed

Flash stops action but blur can
happen with slow shutter speed

Shutter speed too fast, it is closing before flash fires

Shutter speed ok to
trigger flash

Shutter too fast and is
closing before flash fires

Shutter speed 2 settings
faster than sync speed

Lens

3 Basic Lenses

Wide-angle, normal and telephoto are the three basic lens choices you have. Wide-angle and telephoto lenses have very distinct differences. Choose your lens for the effect it will have on your subject.

Normal Lens = Normal View

A normal lens gives you a view close to what you normally see with your eyes.

Lens View Different

The viewfinder on a Point-&-Shoot camera shows you a normal view but the wide-angle lens pushes the subject away so it looks smaller in your photos.

Depth of Focus

Smaller lens openings extend the focus in front and behind the subject. The focus depth is 1/3 in front and 2/3 behind what you are focused on.

Basic Lens Choices

Ultra wide-angle lens:
14mm, 16mm, 18mm, 20mm
Wide-angle lens:
24mm, 28mm, 35mm
Normal lens:
50mm, 55mm
Telephoto lens:
80mm, 105mm, 135mm, 200mm
Long telephoto lens:
300mm, 500mm, 1000mm

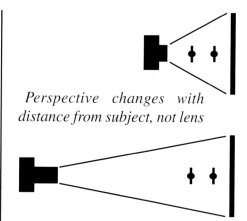

Perspective changes with distance from subject, not lens

Wide-angle pushes subject away, shows more area

Wide-angle lens
pushes subject away

Wide-angle lens
shows more area

Telephoto brings subject closer, shows less area

Telephoto lens
brings subject closer

Telephoto lens
shows less area

Wide-angle lens more background, shorter distance

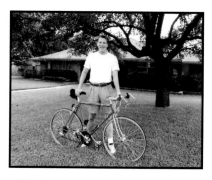

Wide-angle lens shows more
background behind the subject

Wide-angle lens has a shorter
working distance from the subject

Telephoto lens less background, longer distance

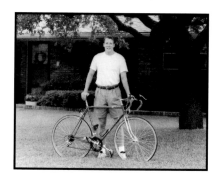

Telephoto lens shows less
background behind the subject

Telephoto lens has a longer
working distance from the subject

61

Wide-angle lens expands the subject area

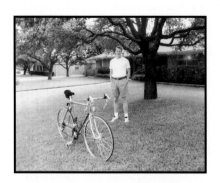

(Subjects were not moved)

Wide-angle lens makes
objects look further apart

Wide-angle lens
expands a scene

Telephoto lens compresses the subject area

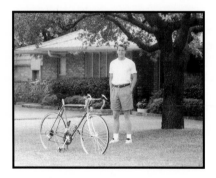

Telephoto lens makes
objects look closer together

Telephoto lens
compresses a scene

Depth of Focus: Large lens opening blurs background

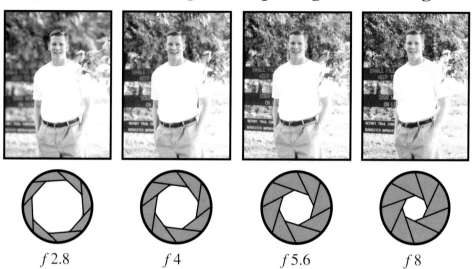

f 2.8 *f* 4 *f* 5.6 *f* 8

Lens + Small opening gives deeper focus

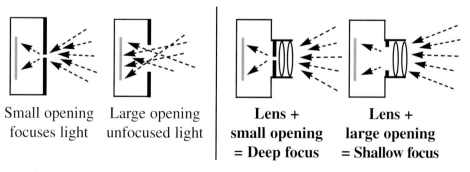

| Small opening focuses light | Large opening unfocused light | **Lens + small opening = Deep focus** | **Lens + large opening = Shallow focus** |

Use a normal lens, for a normal view, like you see

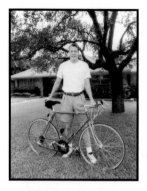

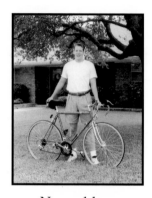

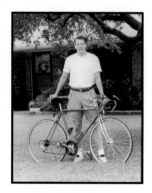

Wide-angle lens
Expanded view

Normal lens
Normal view

Telephoto lens
Compressed view

A macro lens lets you do close-up photographs

Macro lens photo

Macro lens photo

Macro lens photo

Zoom Lens: Set in=Wide-angle, Set out=Telephoto

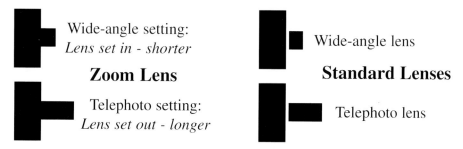

Wide-angle setting:
Lens set in - shorter

Zoom Lens

Telephoto setting:
Lens set out - longer

Wide-angle lens

Standard Lenses

Telephoto lens

Zoom: One lens that adjusts from wide-angle to telephoto

Standard: You must remove the lens to change from wide-angle to telephoto

Choose lens then walk, don't zoom lens, to get view

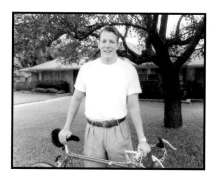

Wide angle: Zoom lens set short (5 feet from subject)

Telephoto: Zoom lens set long (15 feet from subject)

Portrait/Fashion: Four reasons to use a telephoto lens

1. Telephoto lens has more comfortable working distance for subject instead of being right in their face

2. Telephoto lens shows less background to distract attention from subject

3. Telephoto lens blurs background more making it less distracting

4. Telephoto lens compresses and makes people look thinner, wide-angle expands people, and distorts the face and nose in close up photographs.

Telephoto has longer working distance

Telephoto lens compresses subject, less background

Wide-angle has shorter working distance

Wide-angle lens expands subject, more background

Filters can be fun, look at a filter catalog for ideas

Sky light filter protects
lens and filters UV

Diffusion filter
softens subject

Polarizing filter less
reflections, darker
sky and leaves

Holding your camera to prevent camera movement

Holding viewfinder
by camera body

Holding SLR camera
by lens and body

Tripod or mini tripod
to hold camera steady

Same distance from subject / Different views

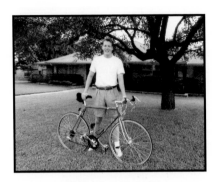

Wide-angle lens
10 feet away

Telephoto lens
10 feet away

Same view / Different distances from subject

Wide-angle lens
10 feet away

Telephoto lens
25 feet away

Film

Film speed

A film's sensitivity to light is rated by its speed. The higher the film speed the more sensitive it is to light.

Try to match the amount of light the film needs with the amount of light you are working in. One film speed can't cover all lighting situations so find the best average film speed for what you need. Flash can be used indoors in low light levels but usually has a maximum distance of 15´.

Film for bright light

100 and 200 speed film needs more light. It is good in bright and normal light situations.

Film for low light

400, 1000 and higher speed film needs less light. It is good in low to normal light situations.

Negative film & Slide film

Negative film is better for prints and prints cost less. Slide film is better for slides. Exposure has to be perfect with slides, negative film is more forgiving of exposure mistakes.

How film is made

Silver is dissolved into tiny little grains and sensitized to light. It is mixed with goop to hold it to the film. The longer it is mixed the more the grains clump together to form bigger grains. This goop (emulsion) is thinly coated on a clear piece of plastic. Where light hits the film the silver grains bond to the film. Where no light hits the film, the silver washes away in the developer when the film is processed. The film is then fixed to make it permanent.

Low speed film is best in bright to medium light

200 Speed film
in bright light outdoors
Print good

200 Speed film
in very low light indoors
Print dark and muddy

High speed film is best in medium to low light

1600 Speed film
in very low light indoors
Print good

1600 Speed film
in bright light outdoors
Print lighter with color shift

Film is a light sensitive mixture on a piece of plastic

Silver is dissolved into tiny
little grains and sensitized to light

Then they mix it into an
emulsion that will stick to film

In the early days it was painted
on glass plates with a brush

Today emulsion is spread on a
clear plastic base by machines

Comparing light filling film to water filling jars

Different film speeds need
different amounts of light

2 gallon jar 1 gallon jar

*Different size jars need
different amounts of water*

Fill negative with amount of light
needed, not half full or overflowing

*Fill jar with amount of water
needed, not half full or overflowing*

Use negative film for prints

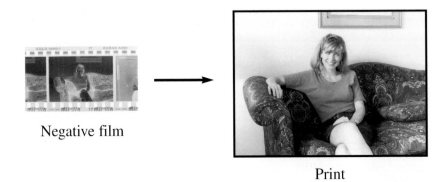

Negative film

Print

Use slide film for slides

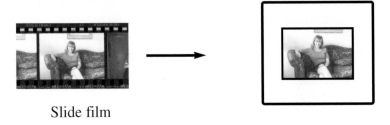

Slide film

Slide

The faster the film speed the larger the grain size

Tiny section of
35mm negative from
8x10 enlargement

100 speed film

200 speed film

100 speed film has smaller grain than 3200 speed film

400 speed film

1600 speed film

3200 speed film

73

High speed film lets you use a faster shutter speed

A faster shutter speed stops action but lets in less light.
High speed film needs less light.

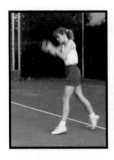 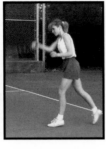 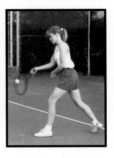

1/60th second	1/125th second	250th second	500th second

Prevent Film Damage

Heat Damage
Don't leave film in car
on a hot day

X-ray Damage
Don't send film in luggage
Ask to have film hand checked

WORKING WITH A LAB

Working with a photo lab

Let the photo lab know if you like your prints warmer or colder, lighter or darker when you turn your film or negatives in. I always ask for warm and rich prints with sun tanned faces. On a reprint it helps to give them a print to match or make changes from. Find a lab with people you can work with. Film processing racks and tanks should be cleaned regularly.

Checklist

If a print doesn't look good check to make sure your negative is good. Sometimes flash photos are printed too light and backlight photos too dark. If the prints look blue ask them to print them warmer. Fluorescent lighting can cause color shifts.

Simple negative filing system

Write the year and roll number on the back of each print and an empty space on the plastic negative sheet when you get them back from the lab. Start with roll 1 at the first of the year and file by year and roll # for that year. Write lightly on the back of prints with a special pencil made for photographs.

Do not throw negatives away

If prints are lost or fade new ones can be made, for future generations. Videos made of photographs and home movies wear out. Negatives are the best & cheapest way to get reprints. Set aside a day to file old negatives by year and file them in shoe boxes. Using archival materials will help keep prints and negatives from fading.

From a good negative you should get a good print

 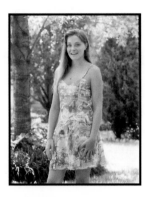 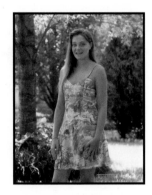

Printed too light Printed good Printed too dark

Look and see if you have a good negative

Negative very under exposed	Negative a little under exposed	Good negative	Negative a little over exposed	Negative very over exposed

Under exposure: Not enough light on the film

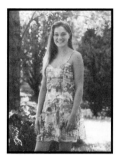

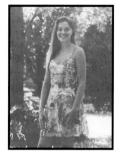

Negative a little under exposed

Print okay

Negative way under exposed

Print dark and muddy

Over exposure: Too much light on the film

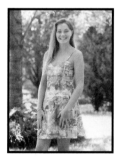

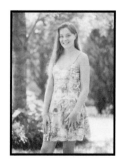

Negative a little over exposed

Print okay

Negative way over exposed

Print losing highlight details

How negatives are processed in three steps

1. The **developer** changes the light sensitive silver crystals that were hit with light into metallic silver, that won't wash away in the fix. **2.** A **stop bath** is used to stop the development. **3. Fix** washes away the unexposed silver and makes the negative permanent so light won't affect it anymore.

Exposed silver stays on the film to create a negative

(Film exposed to light is darker from silver that didn't wash away. Unexposed film is clear because all the silver washed away.)

Taste Test: Do your prefer lighter or darker prints?

Ask a one hour lab to print five 4 x 6 test prints from the same negative, adjusting the prints from lighter to darker. (It should cost about $ 2.50)

-2 lighter	-1 lighter	Normal	+1 darker	+2 darker

How negative film makes a positive print

A light subject area will reflect more light to the negative which creates a dark area on the negative. The dark areas on the negative won't let light through so they are light on the print. *The subject's dark areas are clear on the negative; this lets light through, so they are dark on the print.*

Dark areas on
negative block light

Enlarger shines light
thru negative to paper

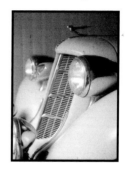

Paper reacts to light
reverse of negative

Taste Test: Do you prefer warmer or colder prints?

Ask a one hour lab to print five 4 x 6 test prints from the same negative, adjusting the color warm to cold. (It should cost about $ 2.50)

-2 colder	-1 colder	Normal	+1 warmer	+2 warmer

35mm negative is longer than an 8 x 10 print

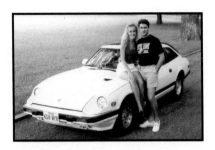

8 x 12 Print is longer
Proportional to 35mm negative

8 x 10 print is shorter
Shorter than 35mm negative

The lab can crop the negative in the enlarger

Guide print with crop marked

Cropped enlargement

Darkroom and Computer digital magic

On a custom enlarged print, to "dodge" an area lightens it and to "burn" an area darkens it. A computer can adjust digital images many ways.

"Dodge" to
lighten an area

"Burn" to
darken an area

Computer/digital
can do everything

Get digital image from any print, negative or slide

Print Scanner
Scans prints to get
digital image

Neg & Slide Scanner
Scans negatives
& slides

Photo CD from photo lab
Negatives or slides scanned
(Lab sends out for scans)

81

Negative filing system: Write year & roll #: 99-7

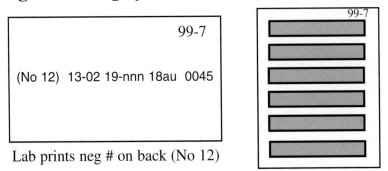

99-7

(No 12) 13-02 19-nnn 18au 0045

Lab prints neg # on back (No 12)

When you get your film back, quickly write the year and roll # on the back of each print and the top of the rolls negative sleeve in blank area
You can start with roll # 1 in January

Get shoe boxes and arrange envelopes by year & roll

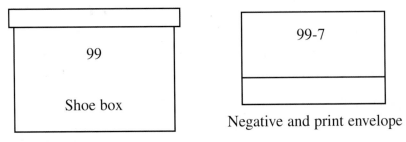

99

Shoe box

99-7

Negative and print envelope

Layout old negatives according to years and # by month. Archival boxes, envelopes and negative sheets will help preserve them better.

Do NOT throw negatives away

How a Camera Works

Camera: Only Two Controls

The camera has only two controls for how much light reaches the film. The **shutter speed** controls how long the light comes in. The **lens opening** size controls how large an opening the light comes through. (Like your eye's pupil which gets larger in low light to let in more light and adjusts to bright light by getting smaller.)

Adjust Amount of Light

Your camera's meter measures the **amount** of light reflecting off the subject. The shutter speed and lens opening control the amount of light. You must set the **film speed** in the camera so its meter knows how much light is needed. Some cameras automatically set the film's speed by reading the bar code on the side of the roll of film.

3-Ways to Calculate Exposure with Your Camera

Manual
You set the shutter speed & lens opening

like using pen & paper

Automatic
You set one and the camera sets the other

like using a calculator

Program
The camera sets both settings

like using a computer

"Let your camera do the math calculations"

83

How a camera works: Only two light controls

The **1. lens opening** and **2. shutter speed** control the amount of light.

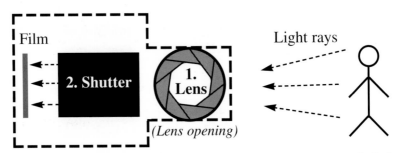

Film Light rays

2. Shutter 1. Lens

(Lens opening)

How much light *Set lens and shutter settings* How much light
does film need? *to control amount of light* is on subject?

Lens control ring and shutter dial, or LCD display

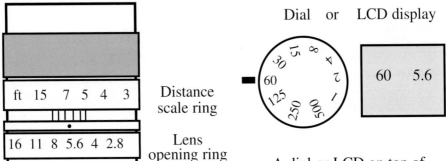

Dial or LCD display

ft 15 7 5 4 3 Distance scale ring

16 11 8 5.6 4 2.8 Lens opening ring

60 5.6

A ring on the lens controls the size of opening inside the lens

A dial or LCD on top of the camera controls the timer for the shutter's speed

Lens Opening: An adjustable opening inside the lens

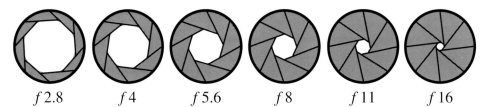

f 2.8 *f* 4 *f* 5.6 *f* 8 *f* 11 *f* 16

These lens openings are units of light called f stops

There are thin metal sheets inside the lens that move in and out to change the lens opening size.

Shutter Speed: A shutter operated by a timer

The shutter inside the camera opens for a fraction of a second to expose the film to light and then closes again

The timer that controls the shutter is set in fractions of a second

(A tripod should be used slower than 1/30th sec)

1/**500** sec ·

1/**250** sec ·

1/**125** sec ·

1/**60** sec ▬

1/**30** sec ▬

1/**15** sec ▬▬

1/**8** sec ▬▬▬

1/**4** sec ▬▬▬▬

1/**2** sec ▬▬▬▬▬

1 second

Units of Light: Double or half the amount of light

SHUTTER SPEED	LENS OPENING	FILM SPEED
30th to **60th**	*f* 4 to *f* 5.6	**100** to **200**
(Fraction of a Second)		

Each shutter speed change lets in twice or half as much light

Each lens opening change lets in twice or half as much light

Double the film speed and it needs half as much light

Trading units of light in different combinations

Blur motion - **Slow shutter** (EXAMPLE) **Fast shutter** - *Stop motion*

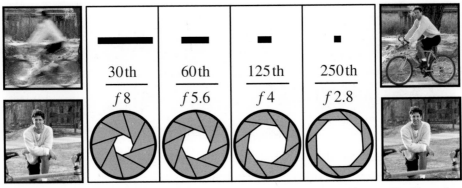

30th	60th	125th	250th
f 8	*f* 5.6	*f* 4	*f* 2.8

Deep focus - **Small opening** **Large opening** - *Shallow focus*

Bathtub theory: Water compared to light

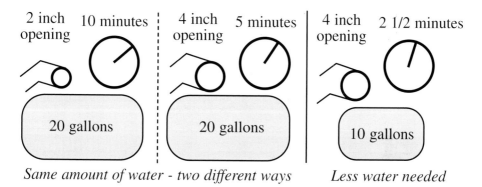

2 inch opening — 10 minutes — 20 gallons

4 inch opening — 5 minutes — 20 gallons

4 inch opening — 2 1/2 minutes — 10 gallons

Same amount of water - two different ways *Less water needed*

What is your lens' largest opening? *f* ___

The larger your lens' maximum opening, the more light it lets in so you can: **1.** Shoot in lower light situations, **2.** Use a faster shutter speed, **3.** Use slower speed film that needs more light.

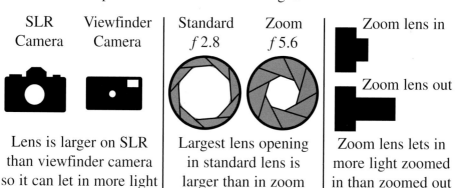

SLR Camera Viewfinder Camera

Standard *f* 2.8 Zoom *f* 5.6

Zoom lens in

Zoom lens out

Lens is larger on SLR than viewfinder camera so it can let in more light

Largest lens opening in standard lens is larger than in zoom

Zoom lens lets in more light zoomed in than zoomed out

87

Buying a Viewfinder camera

1. You look through a viewfinder, not the lens and can't change lenses
2. Smaller and more convenient but less creative controls than SLR

** A camera with a zoom to telephoto adds creativity.*
** A in & out zoom costs less than a continuous zoom.*

Buying an Adjustable SLR Camera

1. You can look through the lens and change lenses
2. More creative controls but larger & less convenient than viewfinder

** An SLR with a built in pop up flash is suggested for convenience.*

Options

___ Auto wind and auto rewind
___ Built in flash and fill flash
___ Backlight button, Spot meter
___ Zoom lens, wide-angle to tele
___ Auto focus
___ Macro capability
___ Self timer or radio remote
___ Weather proof or underwater
___ Auto read for film speed
___ Won't shoot if there is no film
 going thru camera
___ Follow focus for action
___ Panoramic setting

Read Your Camera Manual

Know your camera and what it can do. Learn how to use its special options by reading about them and then trying them. Your cameras special features don't matter if you don't know how to use them.

Learn the minimum focus and flash distances. If you have lost your camera's manual you can send for one to the manufacturer for only a few dollars usually.

*SLR Camera set on Program
is as automatic as a
Point-&-Shoot Camera*

SLR Camera Controls

- **P**rogram: Camera automatically sets both shutter speed and lens opening for you

- **Custom Programs:** Camera automatically sets shutter speed and lens opening for a specific need: *Sports, Portrait, Landscape, Macro*

Portrait	*Sports*	*Landscape/Groups*	*Macro*
Shallow focus	Stop action	Deeper focus	Close-ups

- **M**anual: You set both lens opening & shutter speed according to the camera's light meter reading.

- **S**hutter priority: Set the shutter speed you want and the camera automatically sets lens opening for you. *(within good exposure)*

- **A**perture priority: You set the lens opening and the camera automatically sets the shutter speed for you. *(within good exposure)*

OVERALL PRACTICE LESSON
on one 36 exposure roll of film

Composition

1. Frame subject Vertical
2. Frame subject Horizontal
3. Frame subject Funky Tilt™
4. Crop 3/3 (full length)
5. Crop 2/3
6. Crop 1/3
7. Place on left or right third
8. Place on top or bottom third
9. Place subject on Hot Spot

Angle

10. Subject from front
11. Subject from left side
12. Subject from back
13. Subject from right side
14. Subject from low angle
15. Subject from normal angle
16. Subject from high angle

Lighting

17. Subject in Direct sunlight
18. Subject in Backlight
19. Place subject in Shade
20. Subject on cloudy day

Lighting

21. Subject at sunrise
22. Subject in morning
23. Subject at noon
24. Subject under overhang
25. Subject with flash
26. Place subject in direct light with the background in shade
27. Place subject in shade with background in shade
28. Place subject in shade with background in direct sunlight

Lens

29. Wide-angle / same distance
30. Telephoto / same distance
31. Wide-angle / same image size
32. Telephoto / same image size
33. High angle with telephoto
34. High angle with wide-angle
35. Low angle with telephoto
36. Low angle with wide-angle

C.A.L.L.™ Creative Studies™
Mini 2-3 shots - Medium 4-7 shots - In-Depth 8 + shots

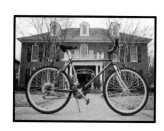

C: Funky tilt, 3/3, fills frame
A: Left-front, high angle
L: Cloudy day
L: Normal lens

C: Horizontal, 3/3
A: Left side, low angle
L: Cloudy day
L: Wide-angle lens

C: Vertical, detail, top third
A: Left side, normal height
L: Cloudy day
L: Telephoto lens

Use C.A.L.L.™ Creative Method to:

1. TAKE great photographs

Use C.A.L.L.™ Card when taking photographs as a creativity checklist..

2. REVIEW your photographs

Use the C.A.L.L.™ Card or Study Card™ to review your photographs.

3. STUDY other photographers photographs

Use C.A.L.L.™ to study books, magazine covers, ads, movies and tv to see the C.A.L.L.™ creative choices they used to create their images.

The C.A.L.L.™ Creative Method....

COMPOSITION

FRAME

Vertical

Horizontal

Funky Tilt™

CROP BY THIRDS

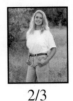
3/3

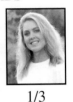
2/3

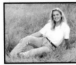
1/3

PLACE ON THIRDS LINE

Left or Right

Top or Bottom

Hot Spots

ANGLE

WALK-AROUND™ ANGLE

Back

Left side

Right side

Front

CAMERA HEIGHT

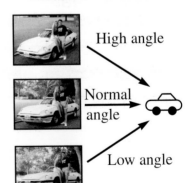

High angle

Normal angle

Low angle

Four steps to taking great photographs

LIGHTING FOUR TYPES OF LIGHT

Direct light

Back light

Shade

D: Cloudy

D: Sunset

Time of Day

Noon Sunrise

Light Ratio

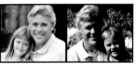
Low ratio High ratio

Light Tools

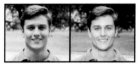
No flash Flash

LENS THREE BASIC LENSES

Wide-angle lens

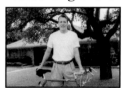
Expand subject/view

Normal lens

Normal view

Telephoto lens

Compress subject/view

Take 2 or more photos to get a good expression

Forced smile	Laughing smile	Relaxed smile	Don't have to
Tense feeling inside	*Fun feeling inside*	*Relaxed feeling inside*	smile or look at camera

Compliment people so they feel good in front of camera

 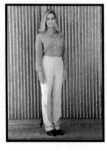 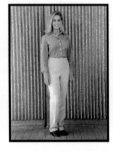

Standing with no posing, *needs help*	Turn subject 15° to 45° degrees from camera	Put all weight on 1 leg, bend other knee	Try both sides body and face to find best